Treasures
in the
National Portrait
Gallery

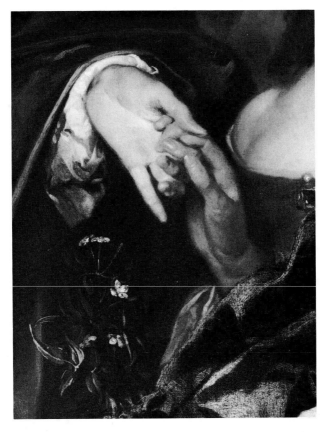

Detail of William, 3rd Viscount Fairfax (1620?–48)
and his wife, Elizabeth, by George Soest, c. 1645–8

John Hayes

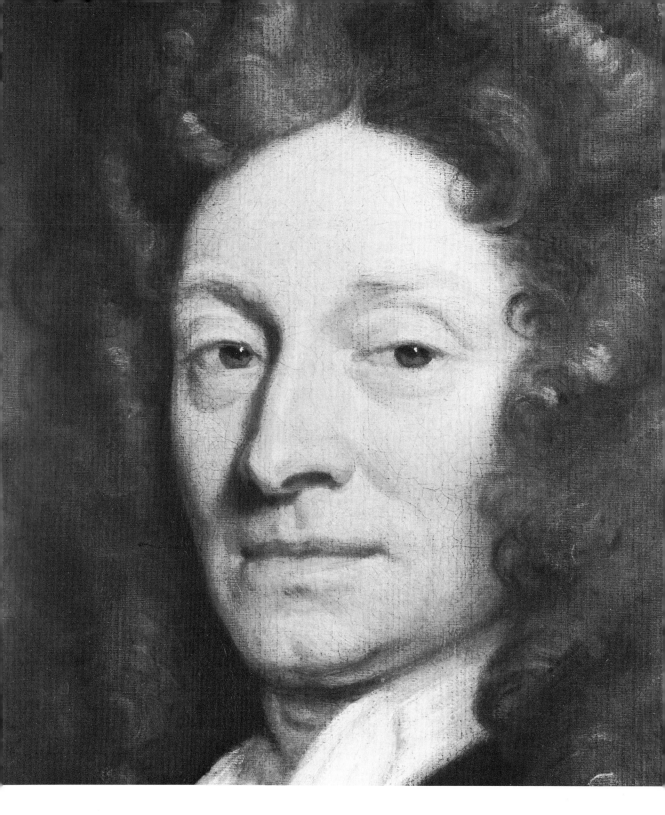

Sir Christopher Wren (1632–1723) by Sir Godfrey Kneller,
1711 (detail)

Preface

Lord Palmerston, winding up the debate on the proposal for a National Portrait Gallery in the House of Commons on 6 June 1856, declared that the object of the new institution was 'to get the best portraits of men distinguished in the history of the country'. Unfortunately, famous people have not always been portrayed by artists of the front rank, nor has the practice of portraiture in this country remained on a consistently high level; thus many of the likenesses acquired by the Gallery have no special merits as works of art. However, the Portrait Gallery is far more than just an iconographic archive; one need scarcely say that the features of a famous person, however feebly delineated, retain an extraordinary power to stir the imagination, and the very first picture to enter the collection, the Shakespeare from the Chandos collection, once owned by the Restoration actor, Thomas Betterton, is a telling example. As Carlyle put it: 'Any representation made by a faithful human creature of that face and figure which he saw with his eyes, and which I can never see with mine, is now valuable to me, and much better than none at all'.

Nonetheless, the gulf between even the most faithful record of a face and figure and a great portrait is immense. It is analogous to the difference between, say, an excellent guide-book to the beauties of the Lake District and Wordsworth's: the one factual and descriptive, the other unquestionably this, too, but communicating infinitely deeper understanding and insight, and expressed in words which, in their aptness, their rhythms and their resonance, often touch us far below our conscious minds. Any good portrait clearly depends upon a close rapport between artist and sitter: the artist's respect for the individual whose *persona* he is trying to interpret in terms of his own particular medium; the sitter's respect for that artist's style, intuitions and integrity. A great portrait results from a fusion of uncommon human understanding on the part of the artist and the artistic imagination at its highest pitch; in other words, of deeply sensitive responses to the character, processes of mind, outward behaviour and conjunctions of physical features of an individual human being, and the ability to express those responses – not only in terms of likeness, which may indeed be distorted, as in a portrait by Picasso or Francis Bacon – but with all the reverberations of which imagery, design, colour and texture are variously capable. Such a portrait, which makes an immediate and powerful impact, and yields only gradually to

analysis, transmits the very essence of personality. Often it transcends individuality and seems to belong to all time. To return to Shakespeare, what would one not give for him to have been painted by Hilliard (plates 8, 9 and 10), or to have travelled abroad to sit to Barocci, or Rubens (plate 16), or, above all, perhaps, to have been sculpted by the young Bernini?

It is not claimed that there are many truly great portraits in the collection; the level is obviously not that of Titian, Velazquez and Rembrandt. But there are many exceptionally fine ones. Holbein's image of Henry VIII (plate 4) stands apart. Legs astride, surcoat swept back over broad shoulders, chilling in demeanour, this is the very incarnation of the Renaissance prince. Gwen John's self-portrait (plate 62), both in design and in firmness of contour and expression, manifests a similar determination, though in her case that of the artistic temperament: fiercely independent and totally committed. Reynolds's *Bute* (plate 36) is derived in pose from the *Apollo Belvedere*, a borrowing which enhances the grandeur of a state portrait in Garter robes; the same artist's *Sterne* (plate 33), with its breadth and simplicity of design and emphasis on head and hands, is intended to remind us of the masterpieces of Titian. Formal and informal can be contrasted in two royal portrait groups (plates 26 and 27). At the other end of the scale from compositional achievement, Hilliard has stripped the mask from the usual icons of Queen Elizabeth (plate 5) and portrayed the woman rather than the monarch, intelligent, alert, determined (plate 8); Rubens has revealed, with the flow of his brush and intuitive slight exaggeration of vital features – piercing eyes, bold nostrils and weaker set of mouth – the core of personality of the proud and sensitive Earl of Arundel (plate 16); the gently intertwined fingers in the exquisitely painted double portrait by Soest (title page) most delicately convey the devotion of Fairfax to his young bride. Skill in composition (plate 37), penetration of character (plate 57) and beauties of handling (plate 35) can be studied and enjoyed in many other portraits in the Gallery than those we have chosen to reproduce in the following pages.

This album of plates, which also gives some idea of the development of the art of portraiture in Britain since the sixteenth century, has been planned as a supplement to the illustrations in the Gallery's souvenir guide.

Note:
Measurements are given in centimetres and
(in brackets) inches, height before width.

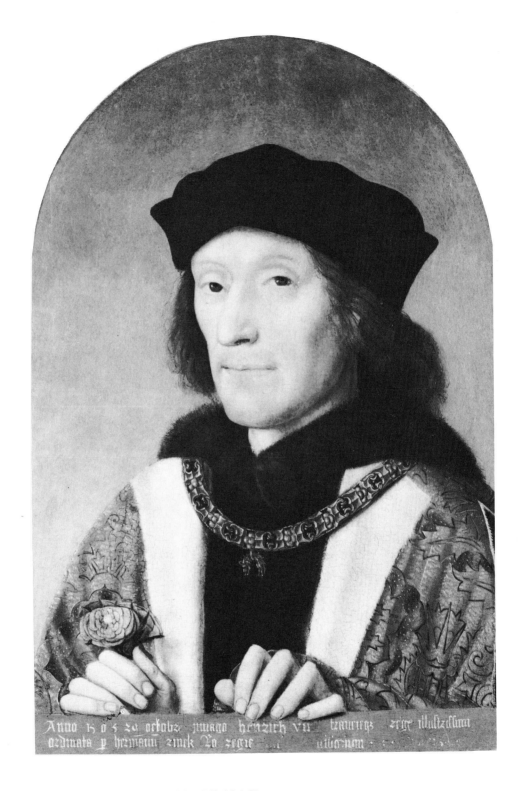

1 Henry VII (1457–1509) by Michiel Sittow, 1505.
 Panel, 42.5 × 30.5 (16¾ × 12)

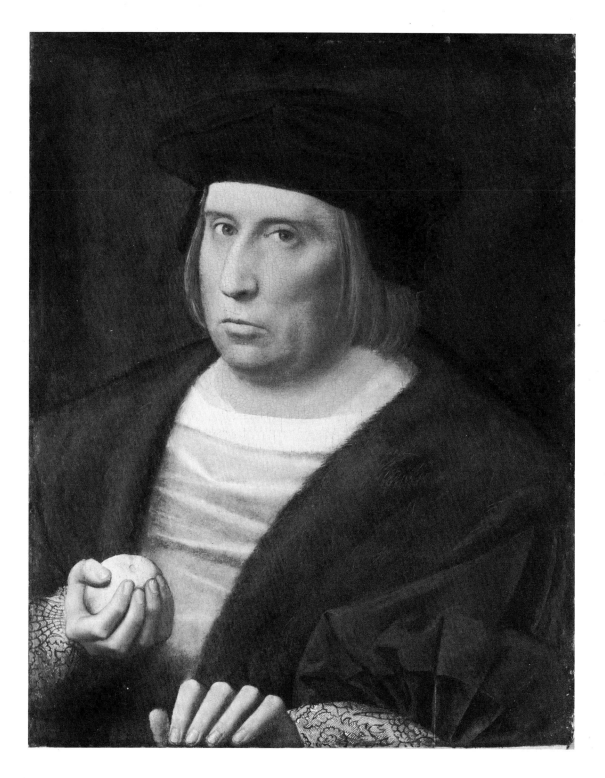

2 John Bourchier, 2nd Baron Berners (1467–1533) by an
unknown artist, *c.* 1525. Panel, 49.6 × 39.4 (19½ × 15½)

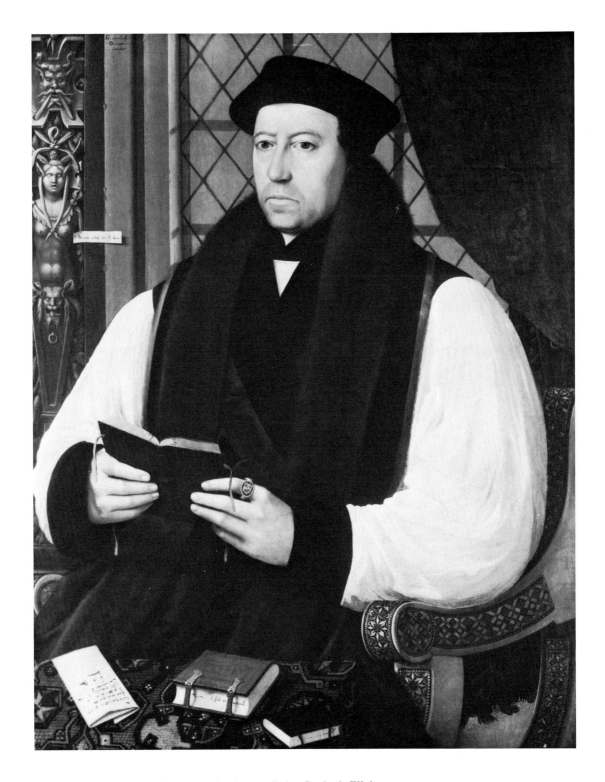

3 Archbishop Thomas Cranmer (1489–1556) by Gerlach Flicke,
1546. Panel, 98.4 × 76.2 (38¾ × 30)

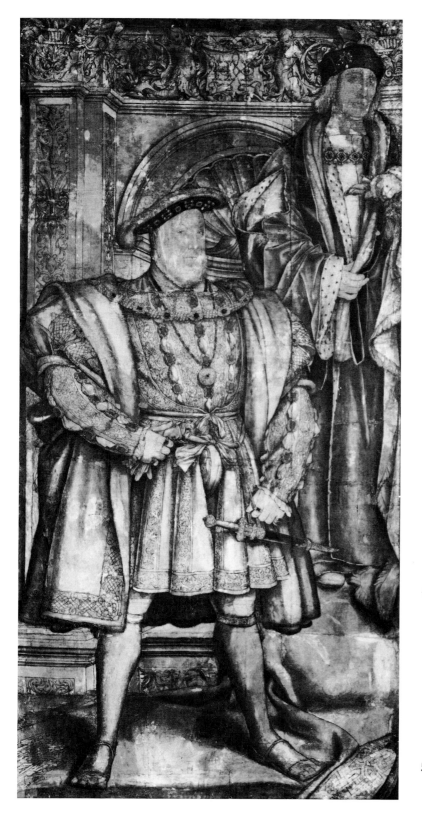

4 Henry VIII (1491–1547), with a
posthumous portrait of Henry VII
(1457–1509), by Hans Holbein the
Younger, *c.* 1537. Cartoon for part
of the fresco surmounting the throne
in the Privy Chamber of Whitehall
Palace. Pen and wash, 257.8 × 137.2
(101½ × 54)

5 Elizabeth I (1533–1603) by Marcus
Gheeraerts the Younger, *c.* 1592.
Canvas, 241.3 × 152.4 (95 × 60)

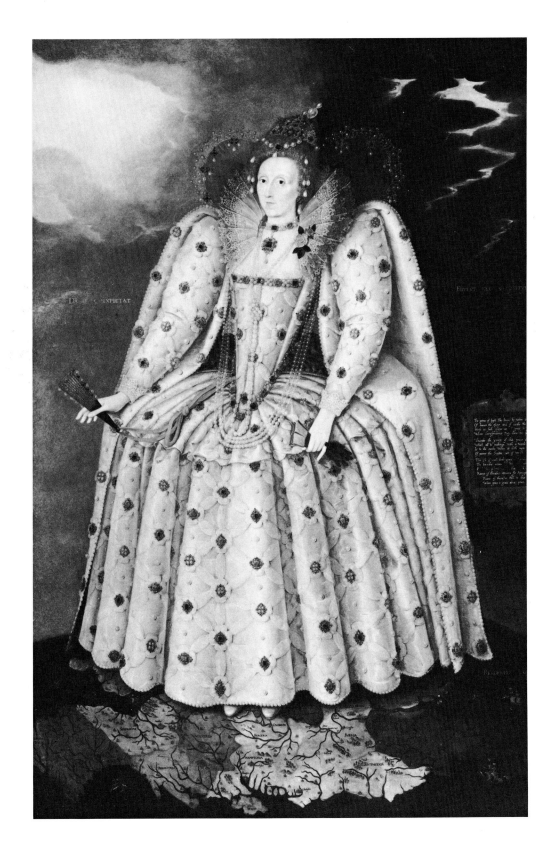

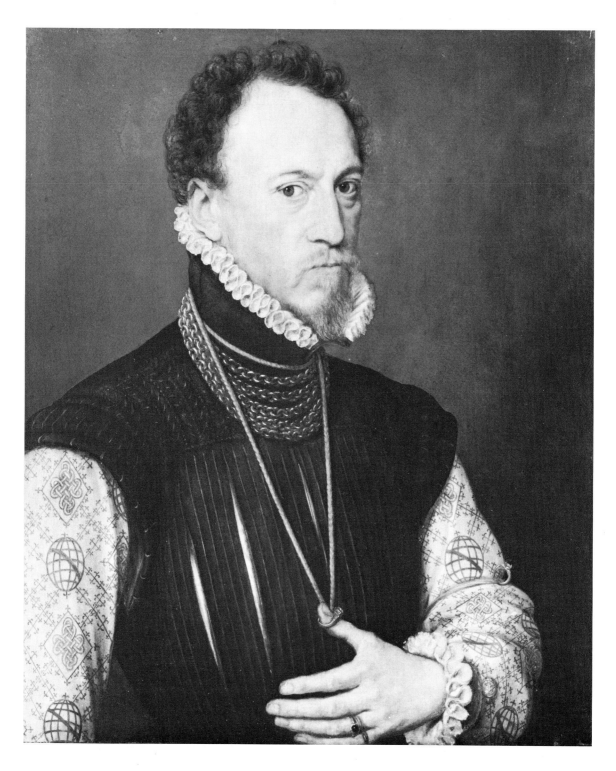

6 Sir Henry Lee (1533–1611) by Antonio Mor, 1568.
Panel, 64.1 × 53.3 (25¼ × 21)

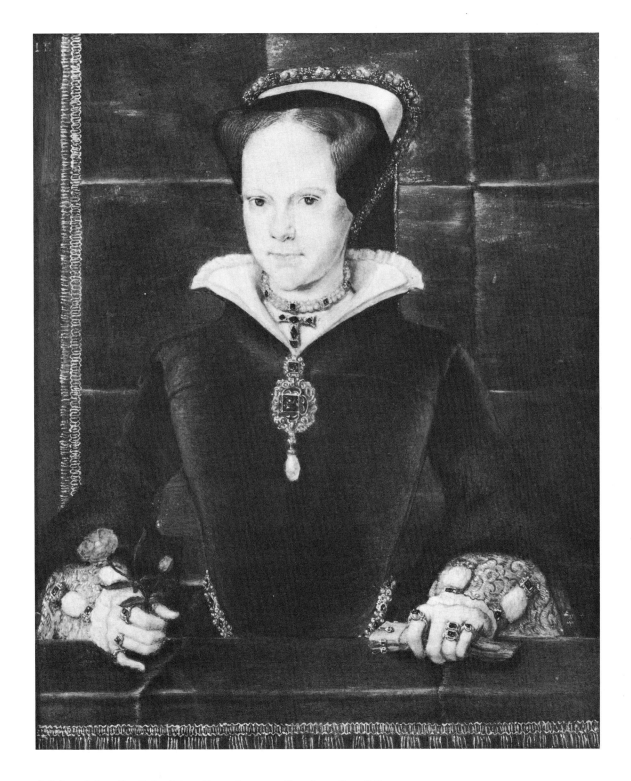

7 Mary I (1516–58) by Hans Eworth, 1554. Panel, 20.6 × 16.8
(8⅛ × 6⅝)

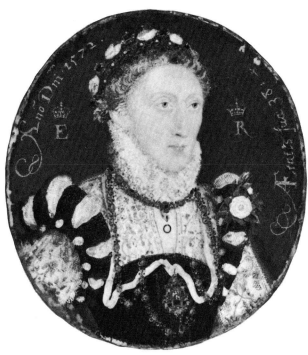

8 Elizabeth I (1533–1603) by Nicholas
Hilliard, 1572. Miniature, 5.1 × 4.8
(2 × 1⅞)

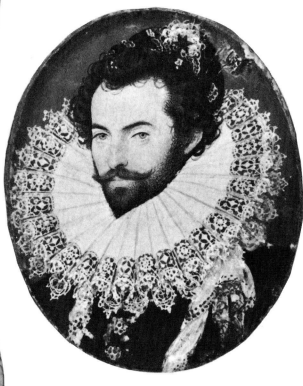

9 Sir Walter Raleigh (1552?–1618)
by Nicholas Hilliard, *c.* 1585.
Miniature, 4.8 × 4.1 (1⅞ × 1⅝)

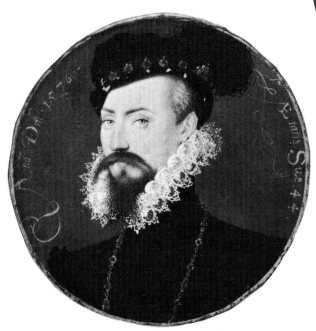

10 Robert Dudley, Earl of Leicester
(1532?–88) by Nicholas Hilliard,
1576. Miniature, 4.4 × 4.4
(1¾ × 1¾)

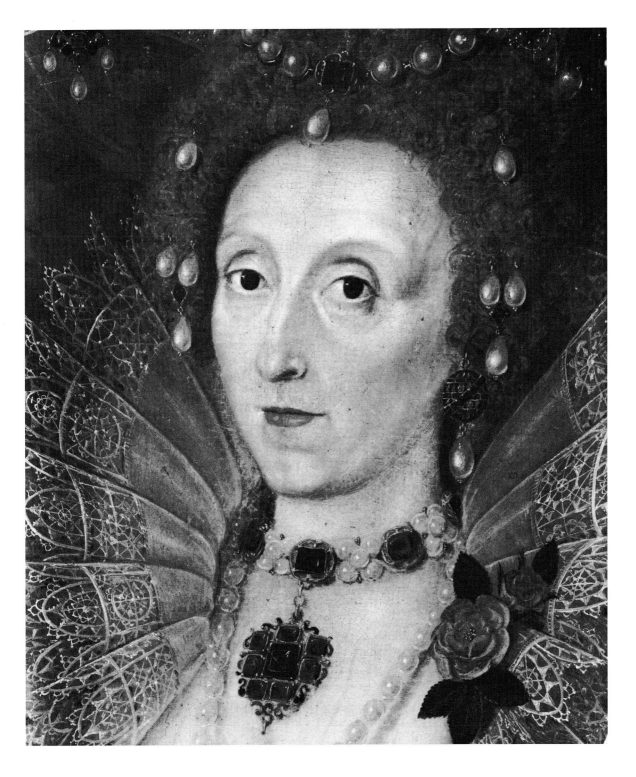

11 Elizabeth I (1533–1603) by Marcus Gheeraerts the Younger,
 c. 1592 (detail from plate 5)

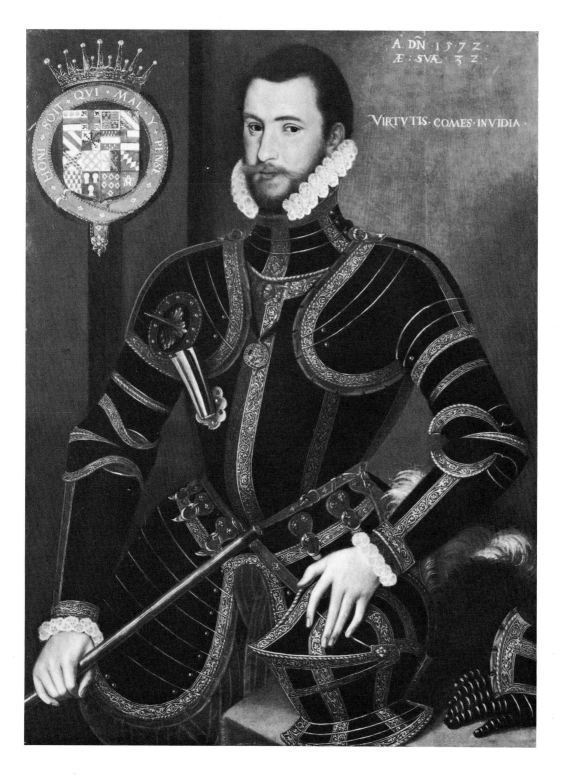

12 Walter Devereux, 1st Earl of Essex (1541?–76) by an unknown artist, 1572. Panel, 109 × 78 (42⅞ × 30¾). (On permanent display at Montacute House, Somerset)

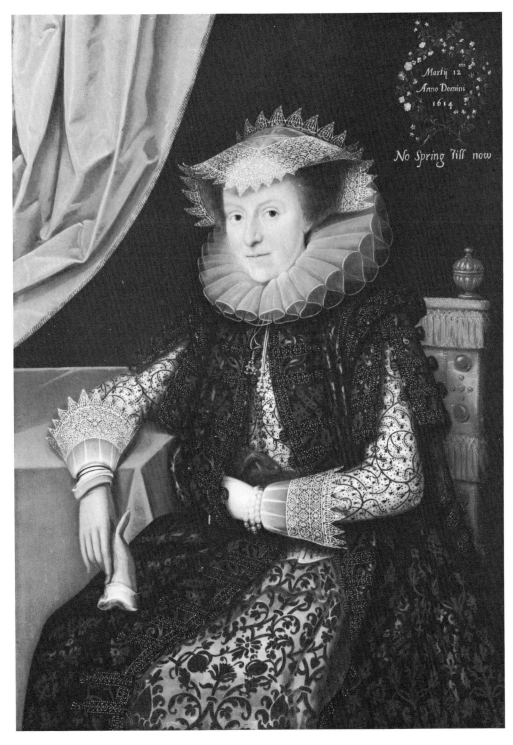

Within the image:
Martij 12
Anno Domini
1614

No Spring Till now

13 Mary Throckmorton, Lady Scudamore (d. 1632) by Marcus
Gheeraerts the Younger, 1614–15. Panel, 114.3 × 82.6 (45 × 32½).
(On permanent display at Montacute House, Somerset)

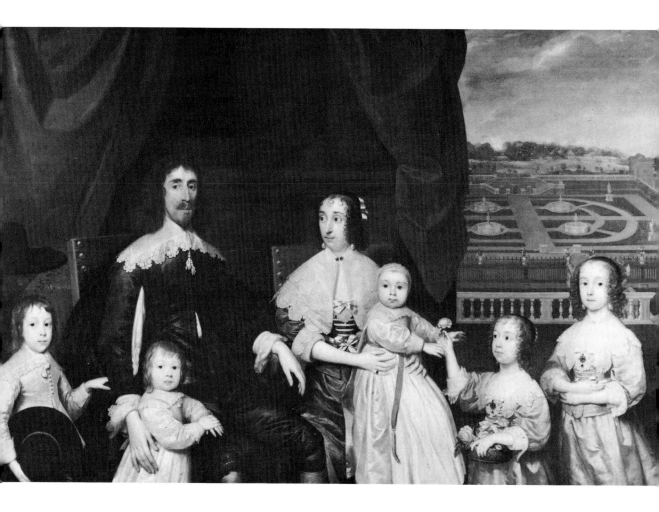

14 Arthur, 1st Baron Capel (1610–49), and his family, by
Cornelius Johnson, *c.* 1639. Canvas, 157.5 × 259.1 (62 × 102)

15 Charles I (1600–49) by Daniel Mytens, 1631.
(Detail, from canvas 215.9 × 134.6 (85 × 53))

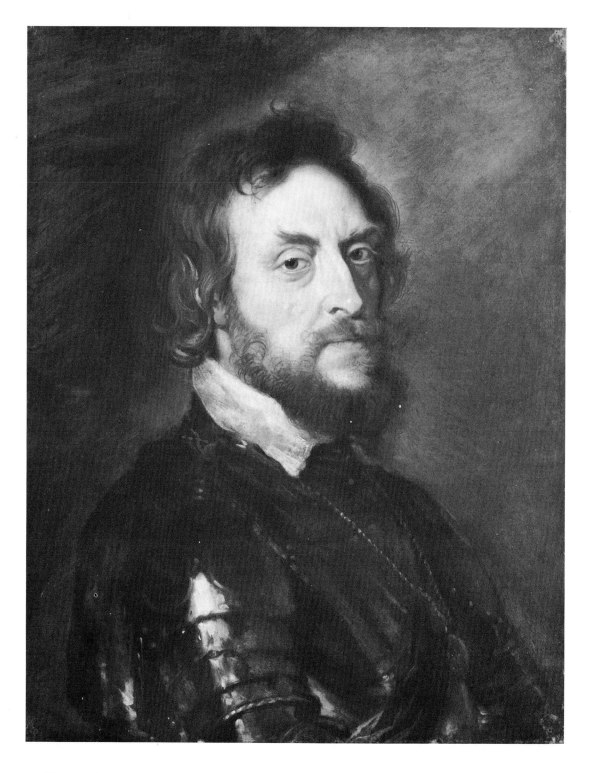

16 Thomas Howard, 2nd Earl of Arundel (1585–1646) by
Sir Peter Paul Rubens, 1629. Canvas, 68.6 × 53.3 (25 × 21)

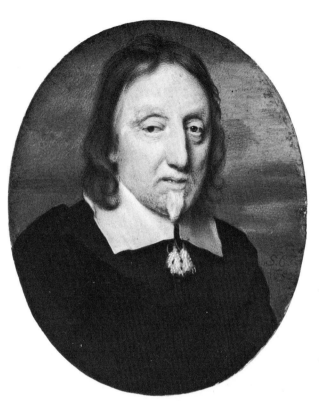

18 William Lenthall (1591–1662) by
Samuel Cooper, 1652. Miniature,
5.4 × 4.4 (2⅛ × 1¾)

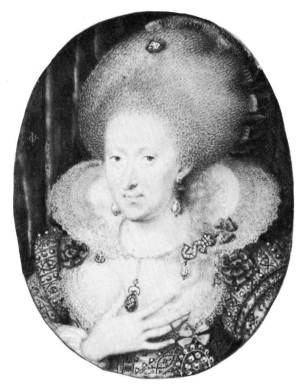

17 Anne of Denmark (1574–1619)
by Isaac Oliver, date unknown.
Miniature, 5.4 × 4.4 (2⅛ × 1¾)

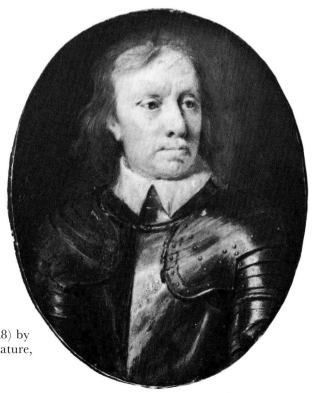

19 Oliver Cromwell (1599–1658) by
Samuel Cooper, 1656. Miniature,
7 × 5.7 (2¾ × 2¼)

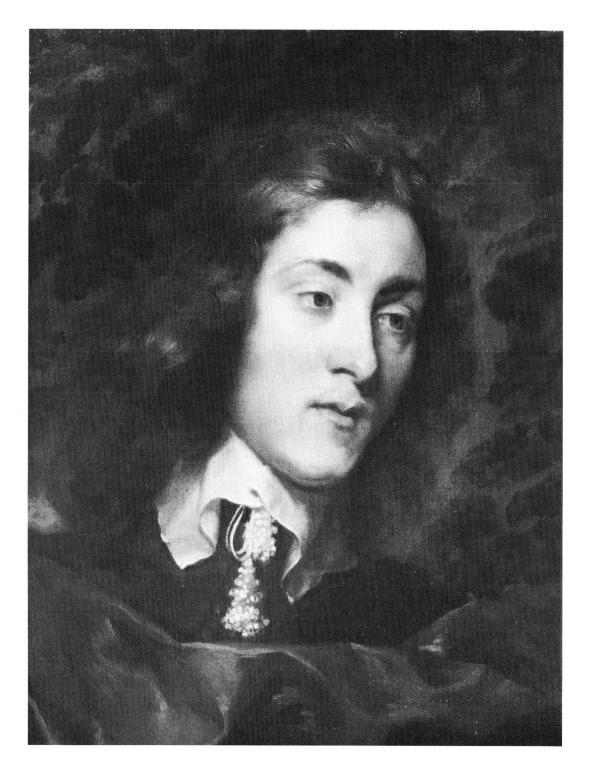

20 William, 3rd Viscount Fairfax (1620?–48) by George Soest,
 c. 1645–8. (Detail from the double portrait with his wife
 Elizabeth, on indefinite loan to the Tate Gallery; canvas,
 139.1 × 174.6 (54¾ × 68¾))

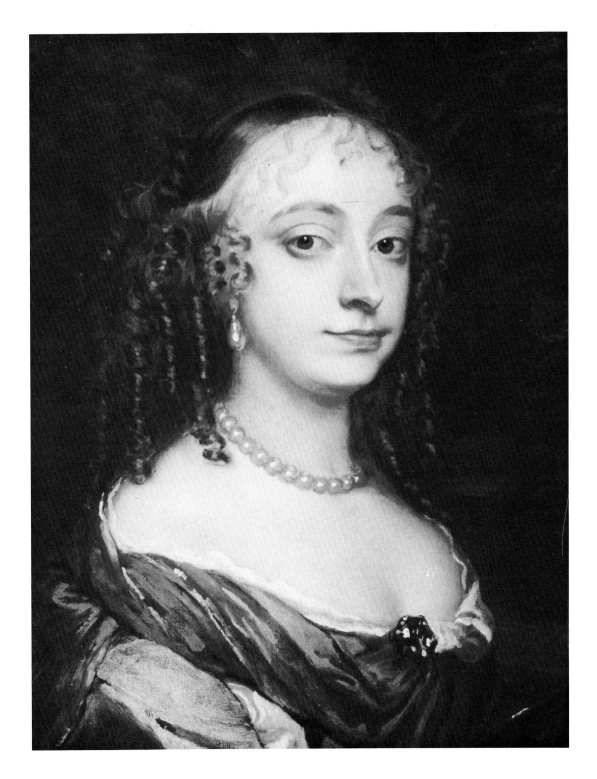

21 Anne Hyde, Duchess of York (1637–71) by Sir Peter Lely,
c. 1660–5. (Detail from the double portrait with her husband,
later James II; canvas, 139.7 × 191.8 (55 × 75½))

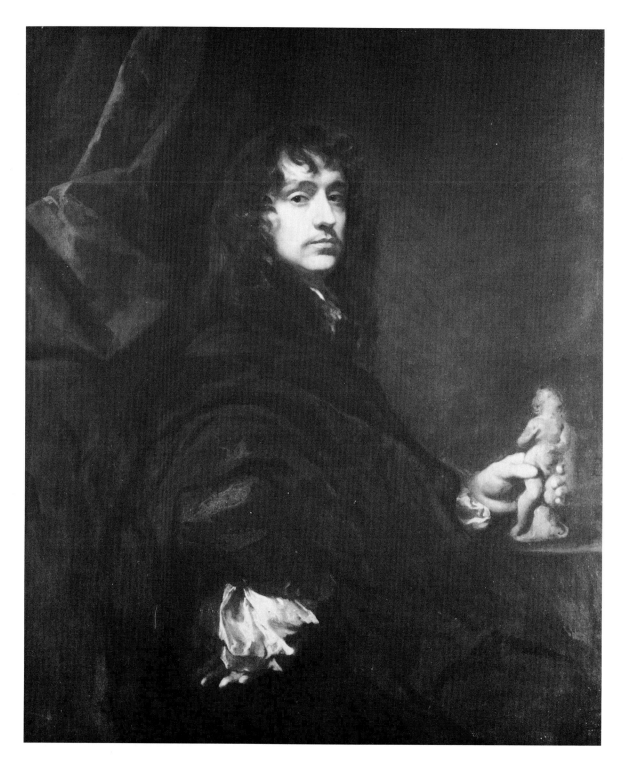

22 Sir Peter Lely (1618–80), self-portrait, *c.* 1660.
Canvas, 107.9 × 87.6 (42½ × 34½)

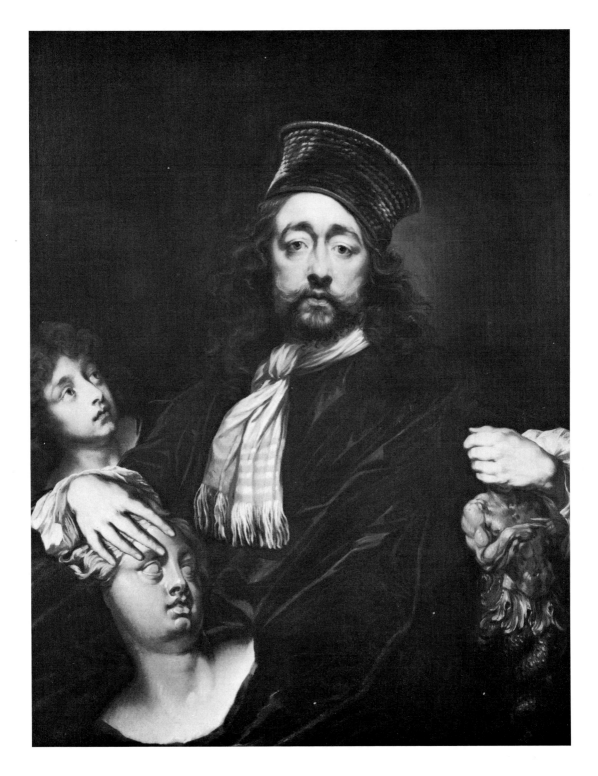

23 Isaac Fuller (1601?–72), self-portrait, *c.* 1670.
Canvas, 125.7 × 100.3 (49½ × 39½)

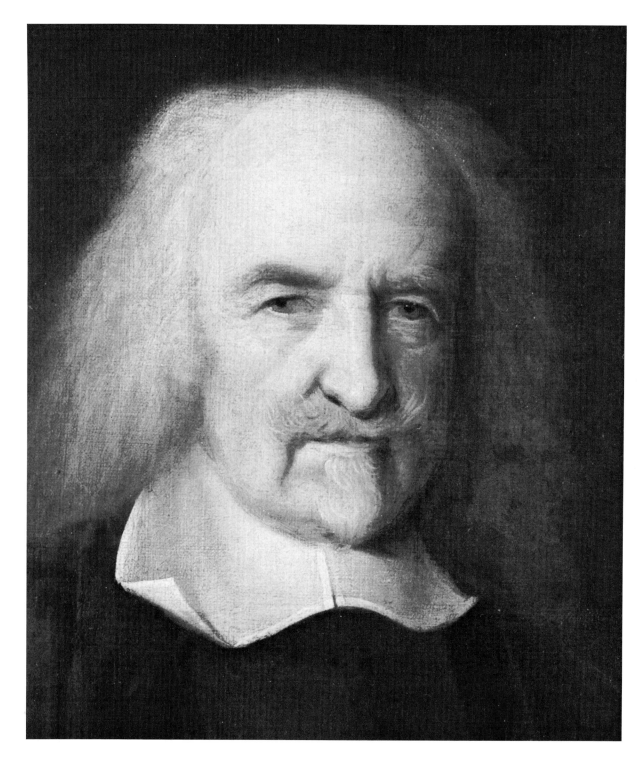

24 Thomas Hobbes (1588–1679) by John Michael Wright,
 c. 1669–70. (Detail , from canvas 66 × 54.6 (26 × 21½))

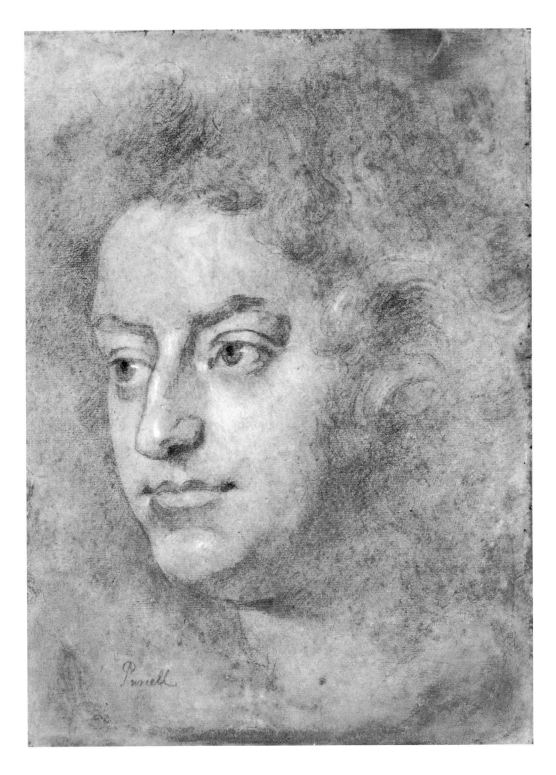

25 Henry Purcell (1659–95), attributed to Sir Godfrey Kneller
but perhaps by Johann Baptist Closterman, *c.* 1695?
Chalk, 38.1 × 28.5 (15 × 11¼)

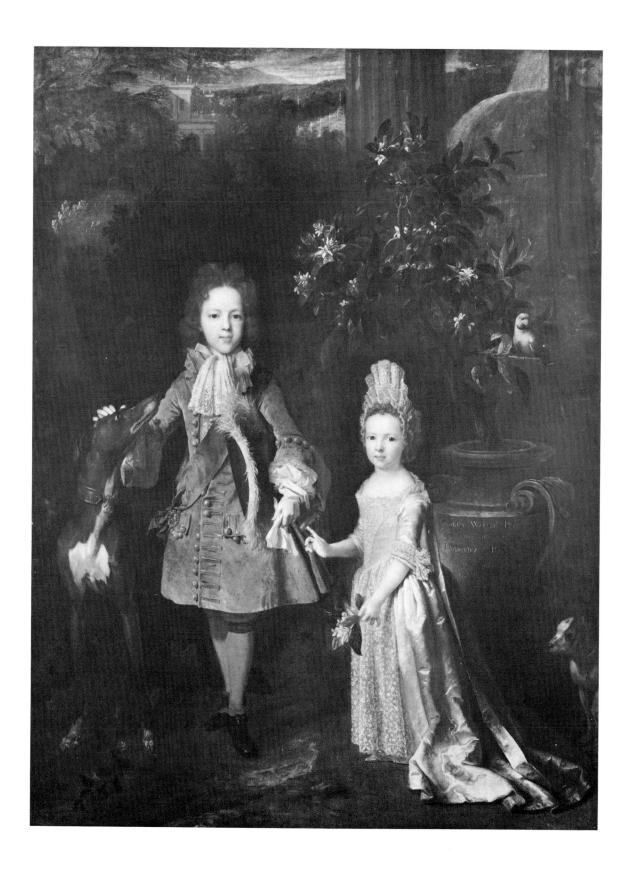

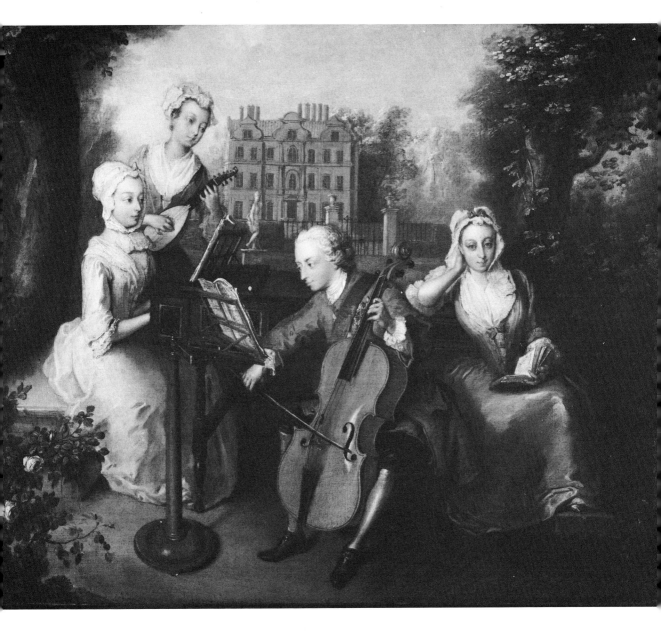

27 Frederick, Prince of Wales (1707–51), with his sisters, from
left to right: Anne (1709–59), Caroline (1713–57) and Amelia
(1711–86), by Philip Mercier, 1733. Canvas, 45.1 × 57.8
(17¾ × 22¾)

left
26 Prince James Francis Edward Stuart (1688–1766) with his
sister, Louisa Maria Theresa (1692–1712), by Nicolas de
Largillière, 1965. Canvas, 193 × 143.5 (75 × 56½)

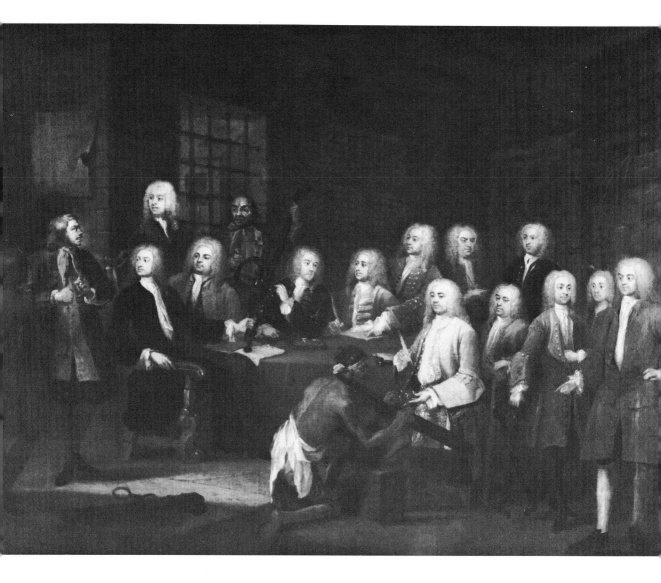

28 The House of Commons Committee examining the Fleet
Prison, by William Hogarth, 1728–9. Canvas, 50.8 × 68.6
(20 × 27)

29 Samuel Richardson (1689–1761) by Joseph Highmore, 1750.
Canvas, 75.6 × 62.9 (29¾ × 24¾)

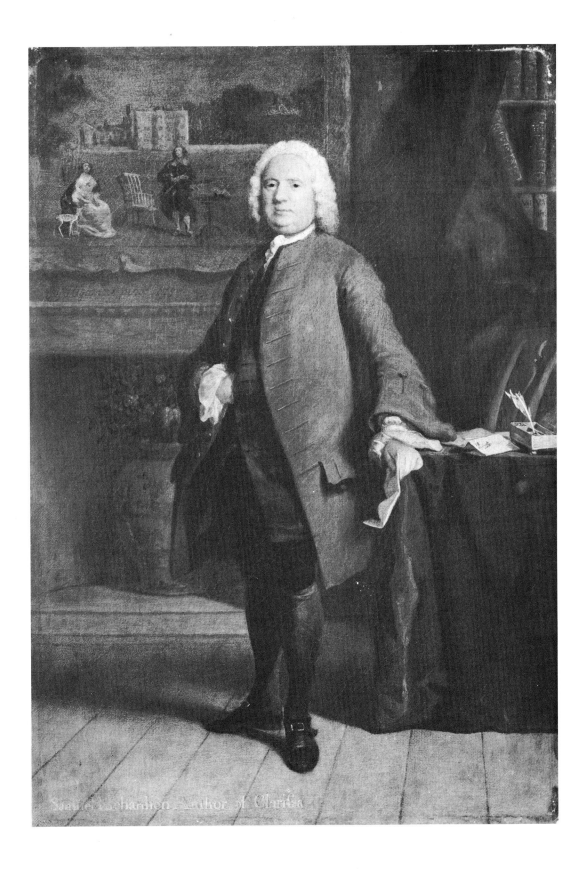
Samuel Richardson, Author of Clarissa

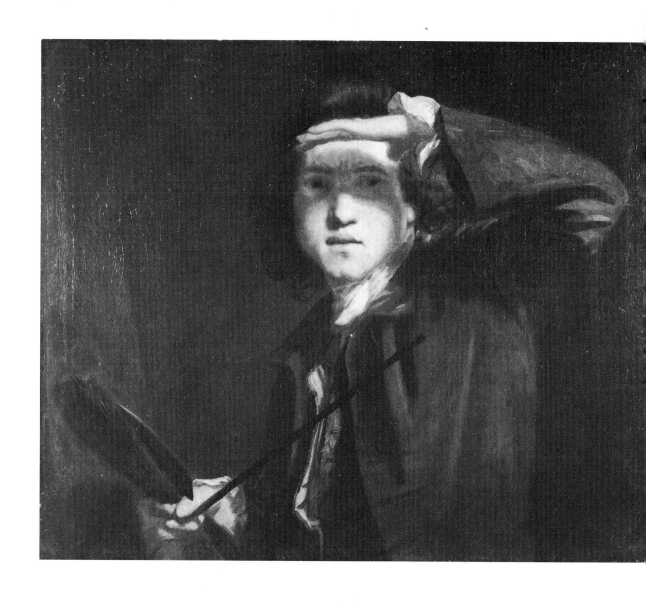

30 Sir Joshua Reynolds (1723–92), self-portrait, 1753–4.
Canvas, 63.5 × 74.3 (25 × 29¼)

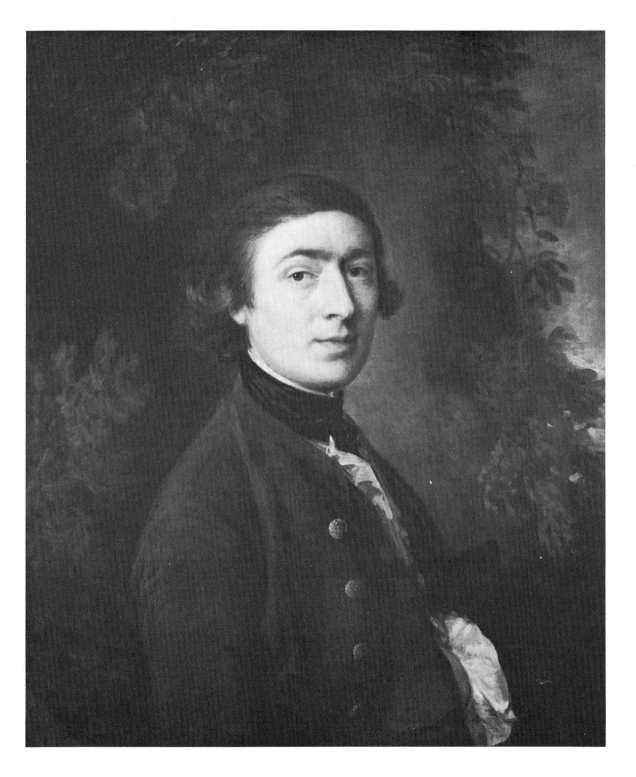

31 Thomas Gainsborough (1727–88), self-portrait, *c.* 1758–9.
Canvas, 76.2 × 63.5 (30 × 25)

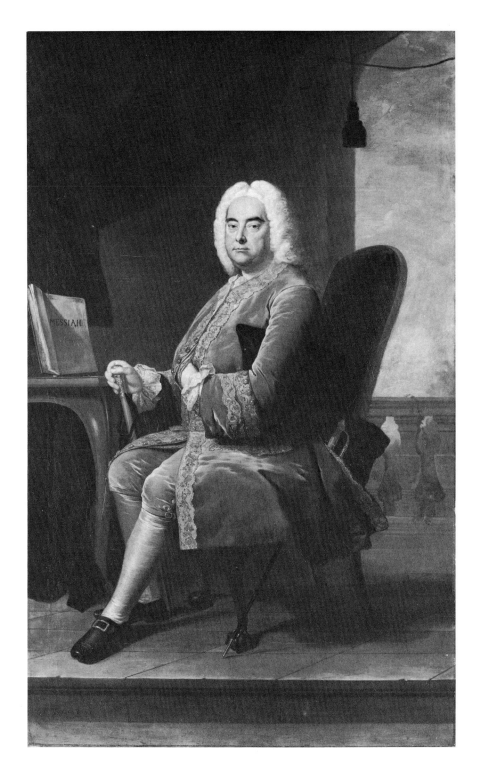

32 George Frederick Handel (1685–1759) by Thomas Hudson,
1756. Canvas, 238.8 × 146.1 (94 × 57½)

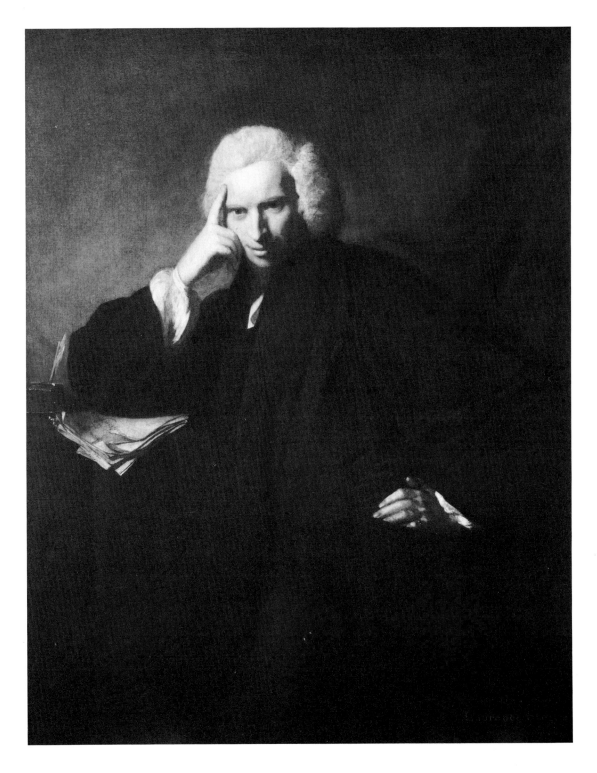

33 Laurence Sterne (1713–68) by Sir Joshua Reynolds, 1760.
Exhibited Society of Artists 1761. Canvas, 127.3 × 100.4
(50⅛ × 39½)

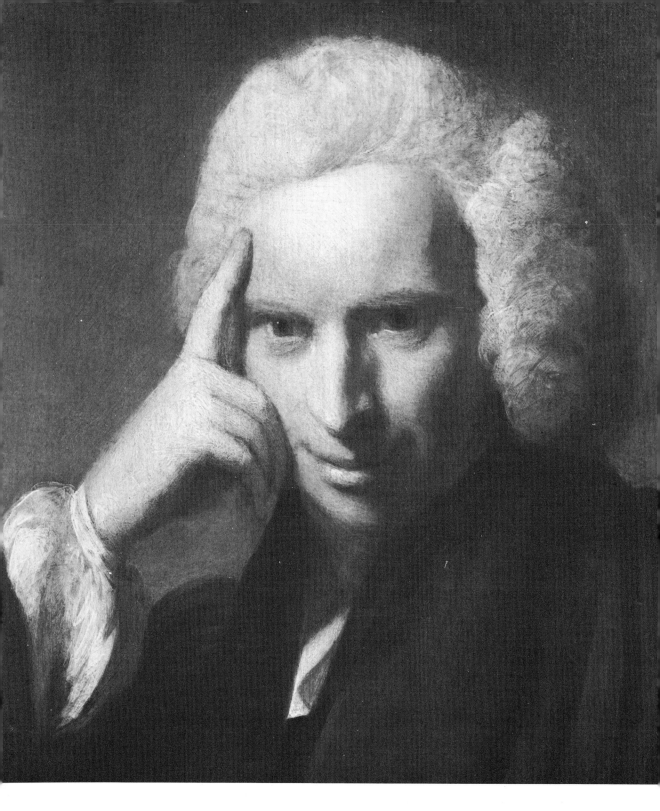

34 Laurence Sterne (1713–68) by Sir Joshua Reynolds, 1760.
(Detail from plate 33)

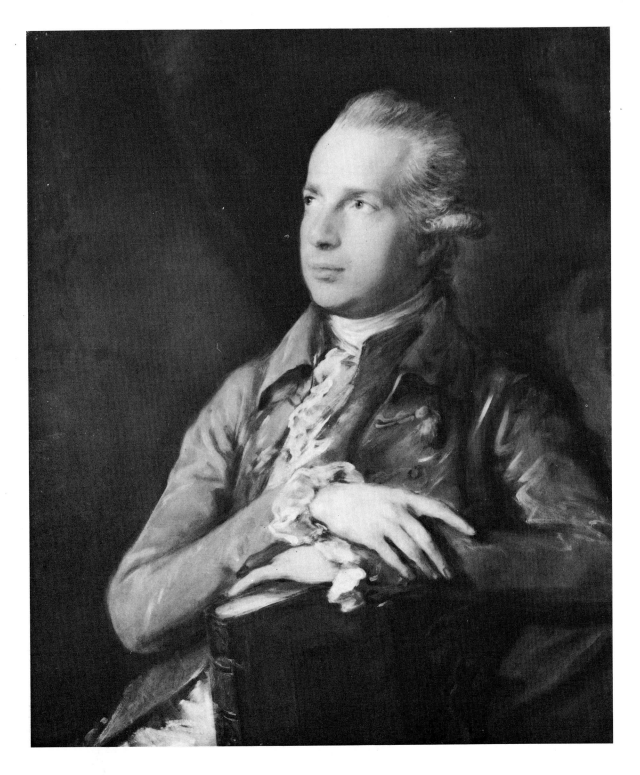

35 George Colman (1732–94) by Thomas Gainsborough,
 c. 1775–80. Canvas, 72.4 × 59.1 (28½ × 23¼)

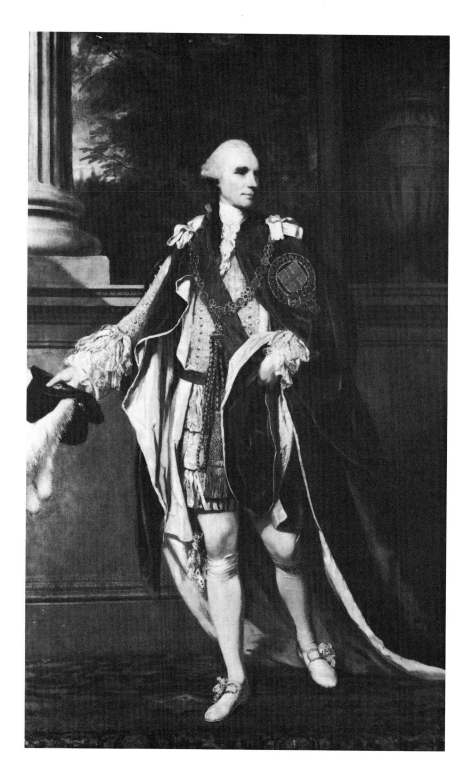

36 John, 3rd Earl of Bute (1713–92) by Sir Joshua Reynolds,
1773. Canvas, 236.9 × 144.8 (93¼ × 57)

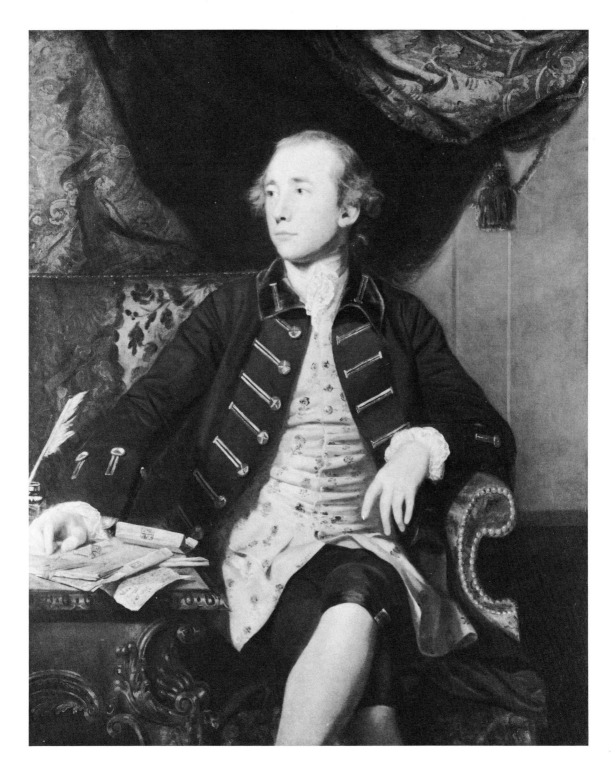

37 Warren Hastings (1732–1818) by Sir Joshua Reynolds,
1766–8. Canvas, 126.4 × 101 (49¾ × 39¾)

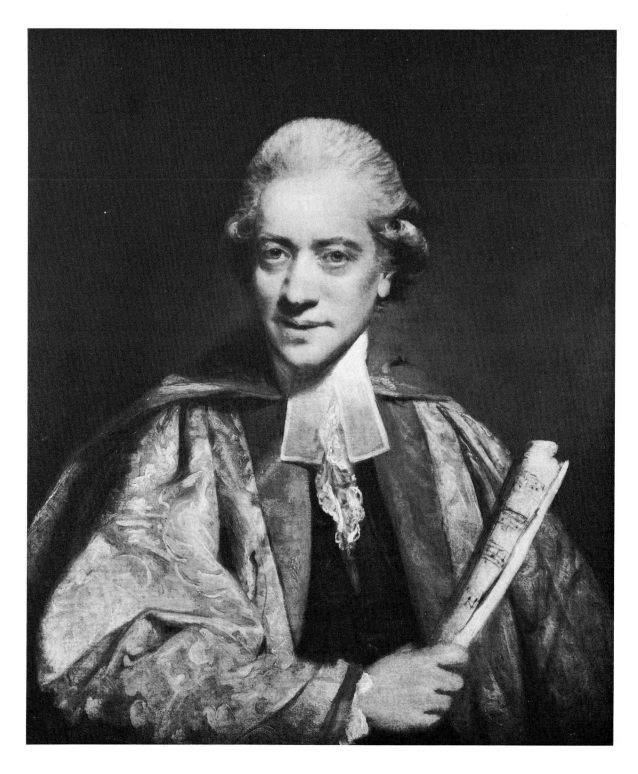

38 Charles Burney (1726–1814) by Sir Joshua Reynolds, 1781.
Canvas, 74.9 × 61 (29½ × 24)

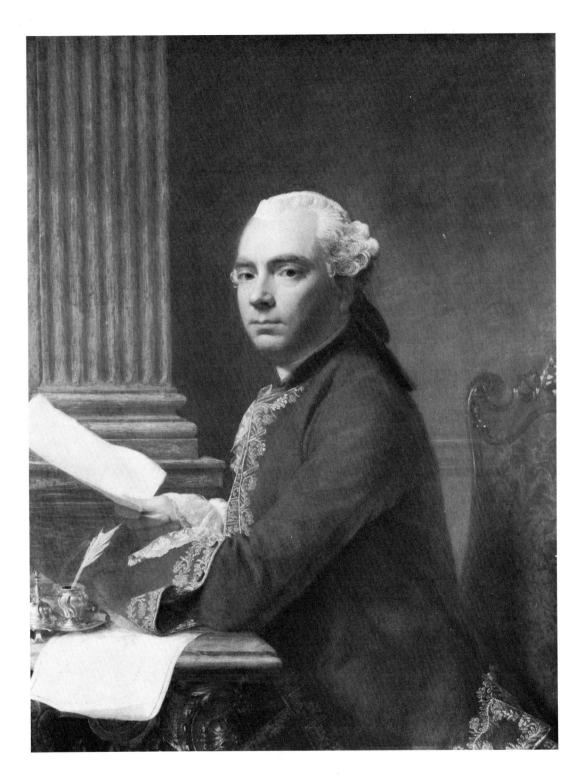

39 Robert Wood (1717?–71) by Allan Ramsay, 1755.
Canvas, 99.1 × 75 (39 × 29½)

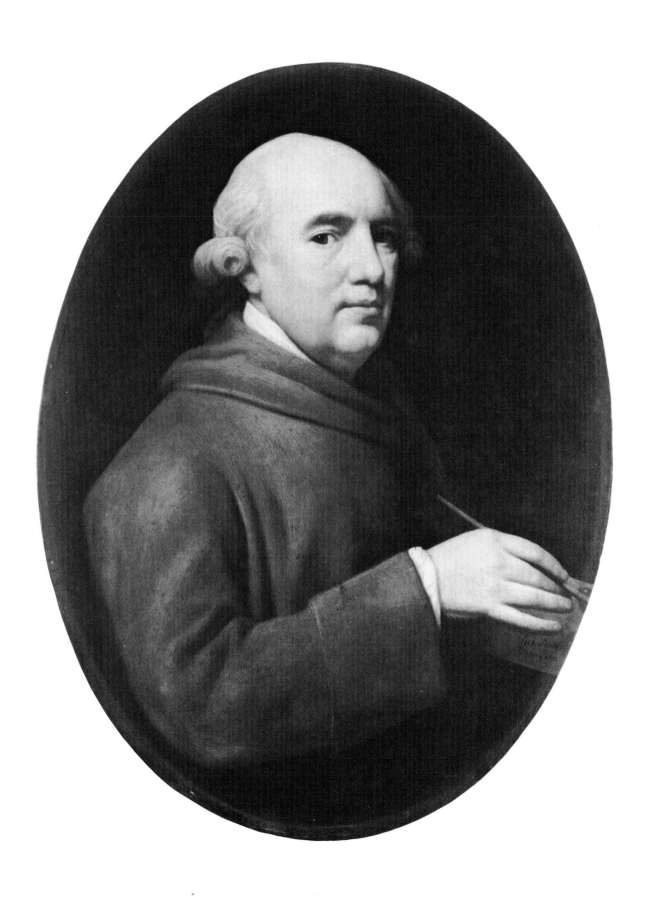

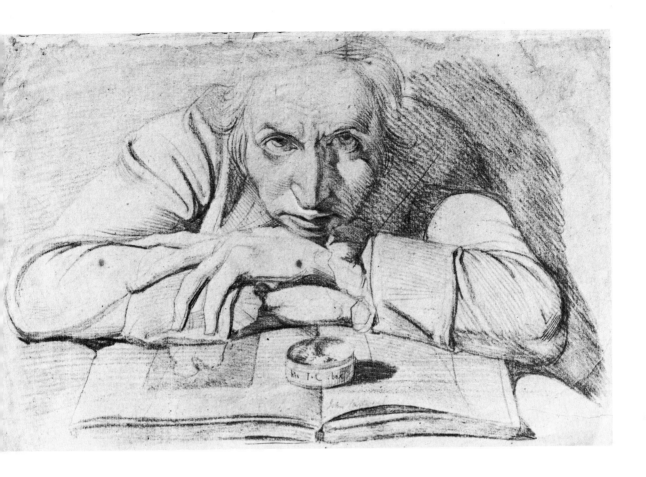

41 Henry Fuseli (1741–1825), self-portrait, *c.* 1779.
Pencil, 32.4 × 50.2 (12¾ × 19¾)

left:
40 George Stubbs (1724–1806), self-portrait, 1781. Enamel on
Wedgwood plaque, oval, 67.6 × 51.1 (26⅝ × 20⅛)

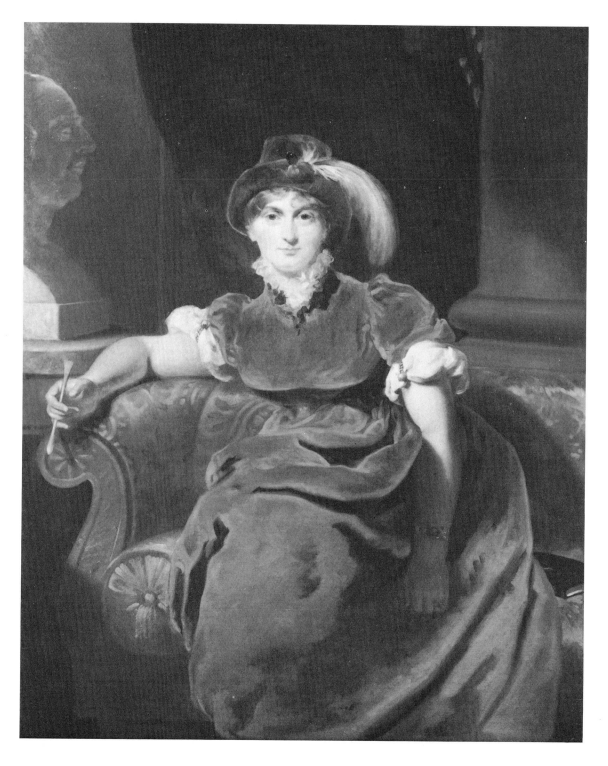

42 Caroline of Brunswick (1768–1821) by Sir Thomas Lawrence, 1804. Canvas, 140.3 × 111.8 (55¼ × 44)

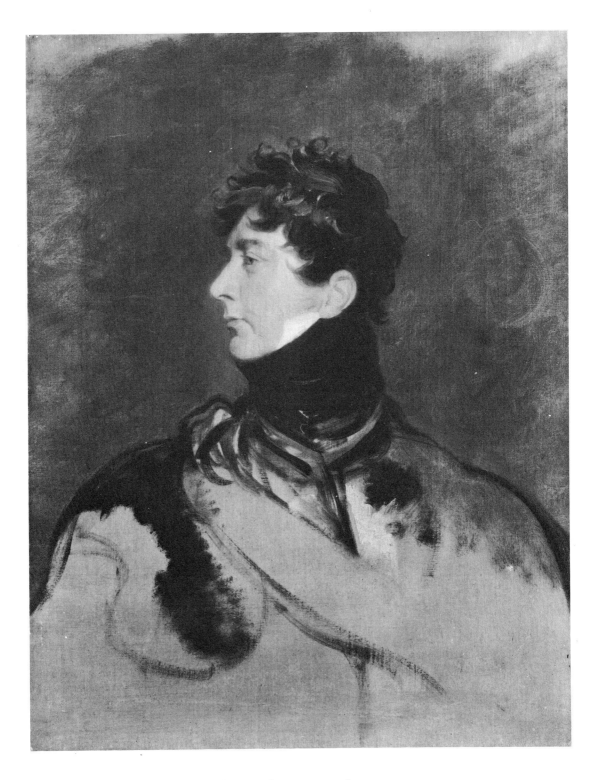

43 George IV (1762–1830) by Sir Thomas Lawrence, *c.* 1820.
Canvas, 68.6 × 52.1 (27 × 20½)

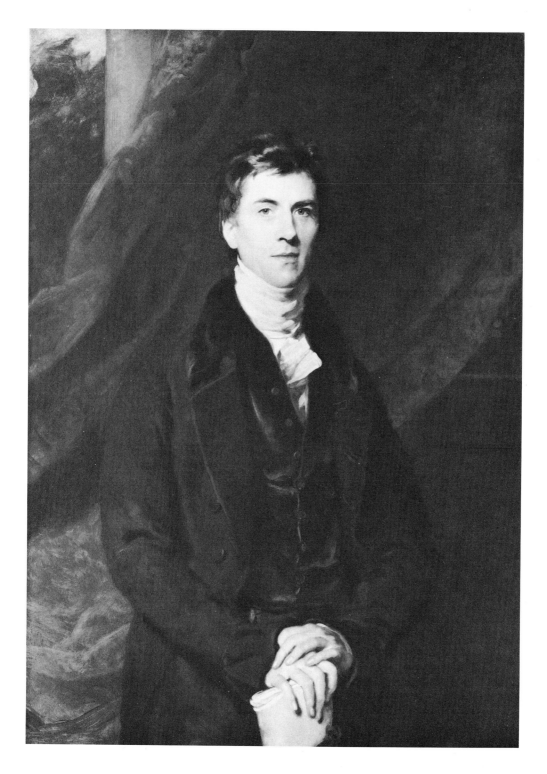

44 Henry, 1st Baron Brougham (1778–1868) by Sir Thomas
Lawrence, *c.* 1825. Panel, 111.8 × 78.8 (44 × 31)

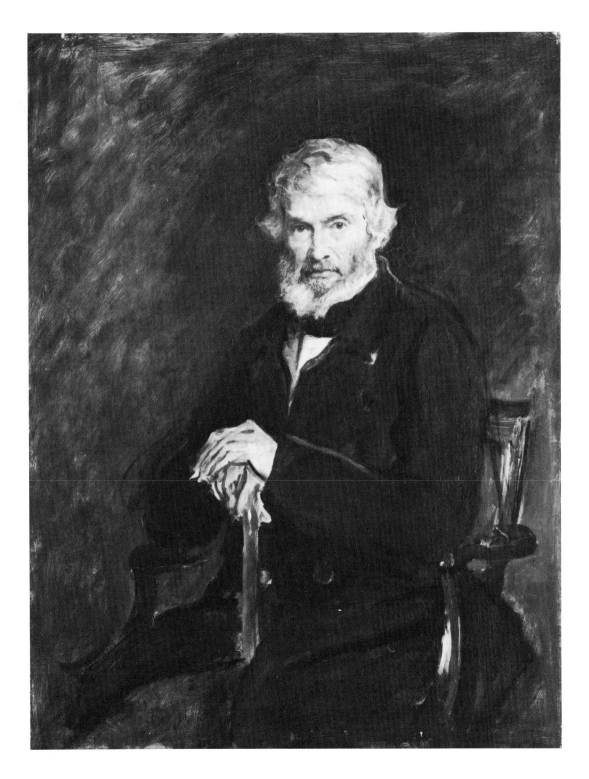

45 Thomas Carlyle (1795–1881) by Sir John Millais, 1877.
Canvas, 116.8 × 88.3 (46 × 34¾)

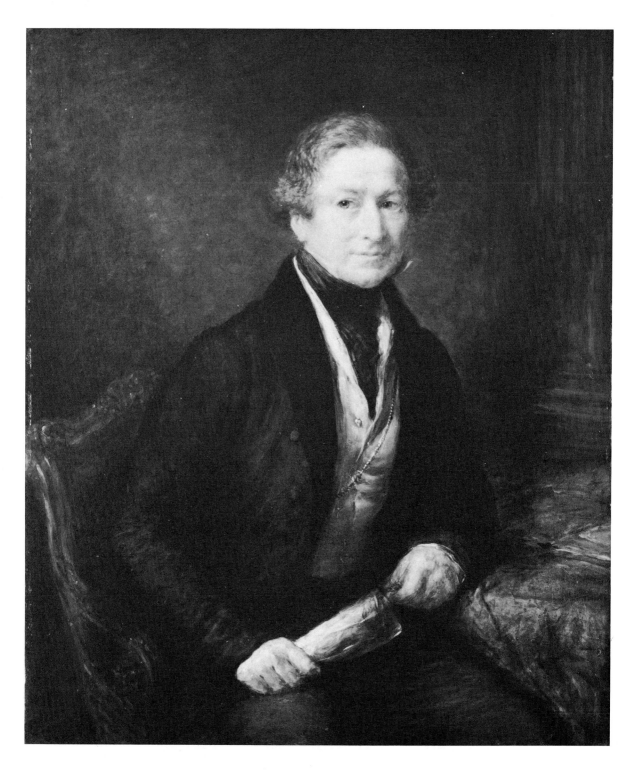

46 Sir Robert Peel (1788–1850) by John Linnell, 1838.
Panel, 45.4 × 37.8 (17⅞ × 14⅞)

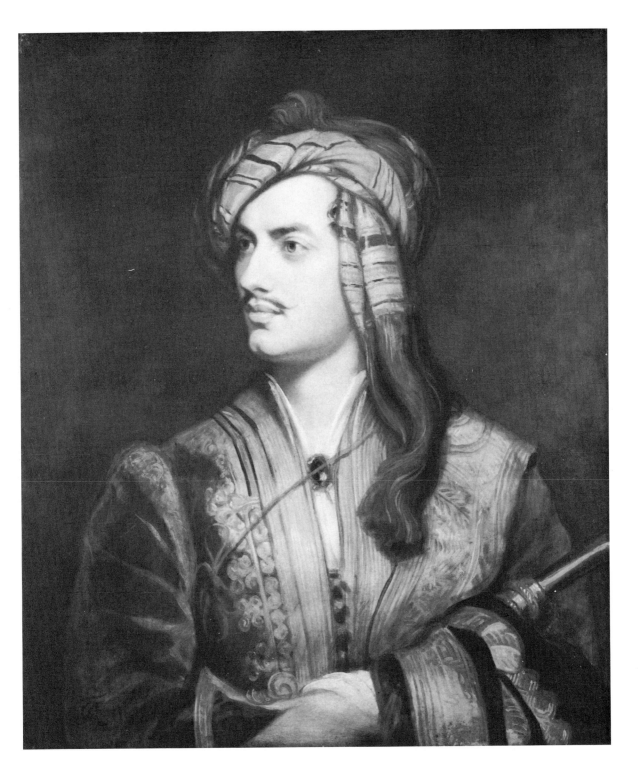

47 George, 6th Baron Byron (1788–1824) by Thomas Phillips.
Exhibited Royal Academy 1814. Canvas, 74.9 × 62.2
(29½ × 24½)

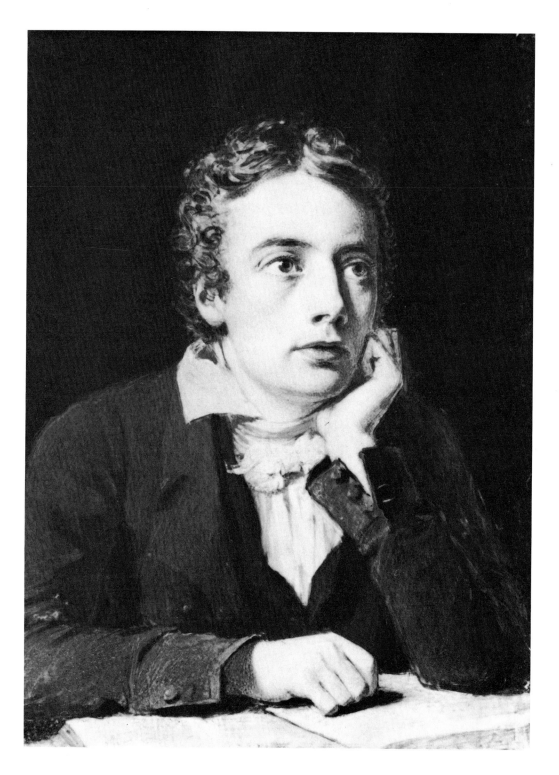

48 John Keats (1795–1821) by Joseph Severn, 1819.
Miniature, 10.8 × 7.9 (4¼ × 3⅛)

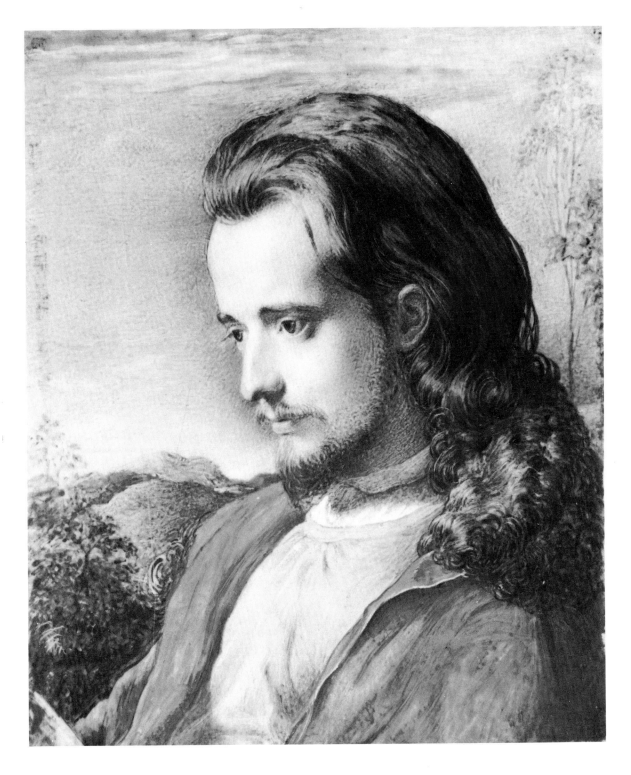

49 Samuel Palmer (1805–81) by George Richmond, 1829.
Miniature, 8.3 × 6.4 (3¼ × 2½)

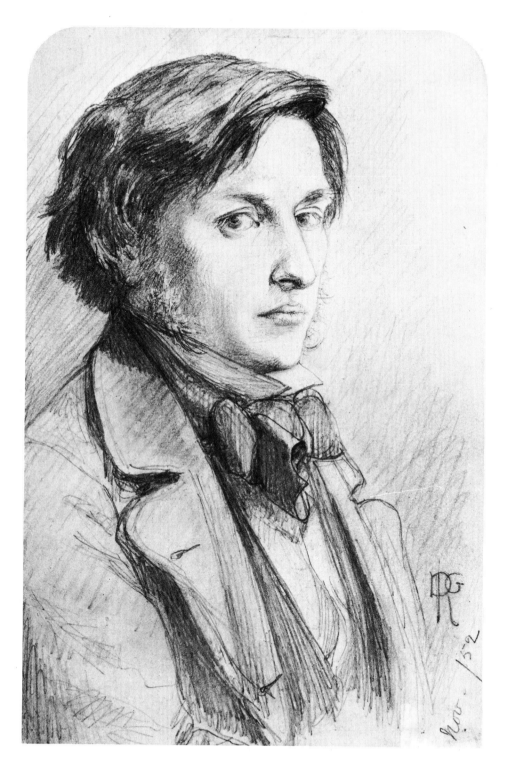

50 Ford Madox Brown (1821–93) by Dante Gabriel Rossetti,
1852. Pencil, 17.1 × 11.4 (6¾ × 4½)

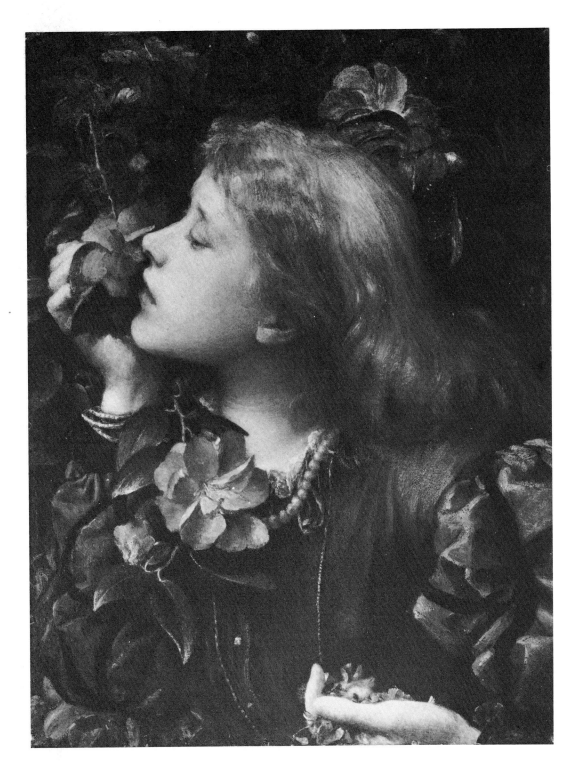

51 Ellen Terry (1847–1928), 'Choosing', by George Frederic Watts.
Exhibited Royal Academy 1864. Panel, 47 × 35.6 (18½ × 14)

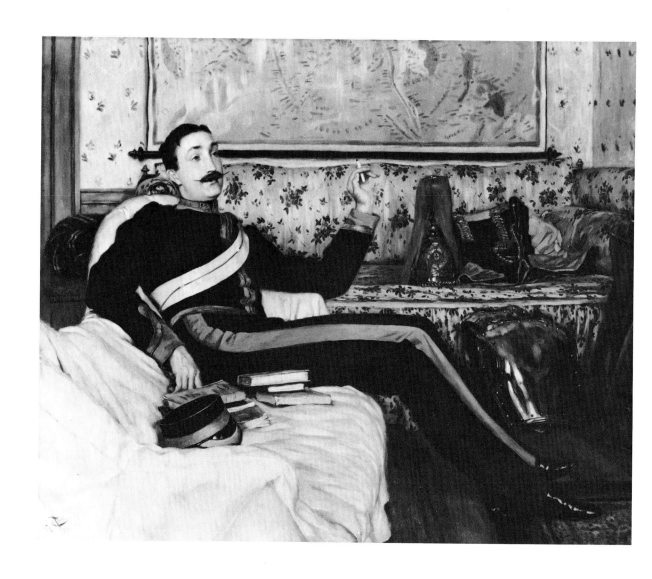

52 Frederick Burnaby (1842–85) by James Tissot, 1870.
Panel, 49.5 × 59.7 (19½ × 23½)

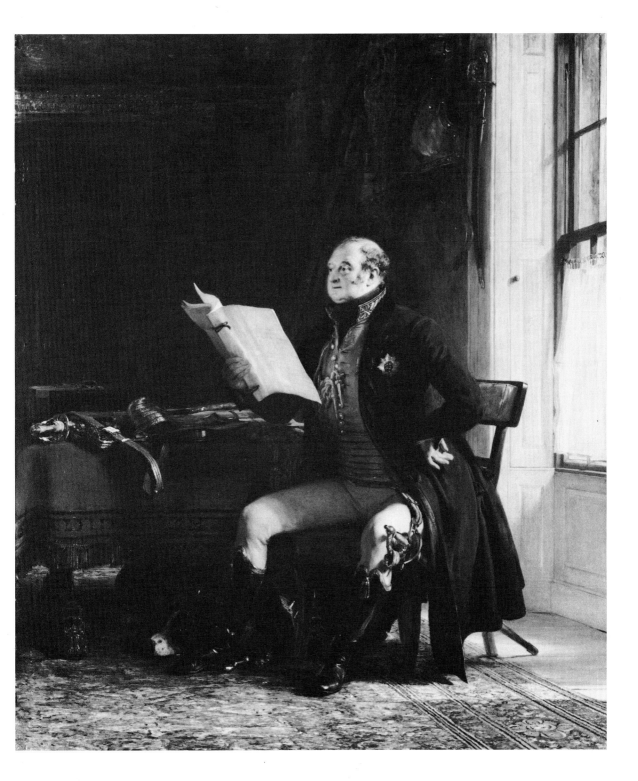

53 Frederick, Duke of York (1763–1827) by Sir David Wilkie,
1823. Panel, 59.1 × 52.1 (23¼ × 20½)

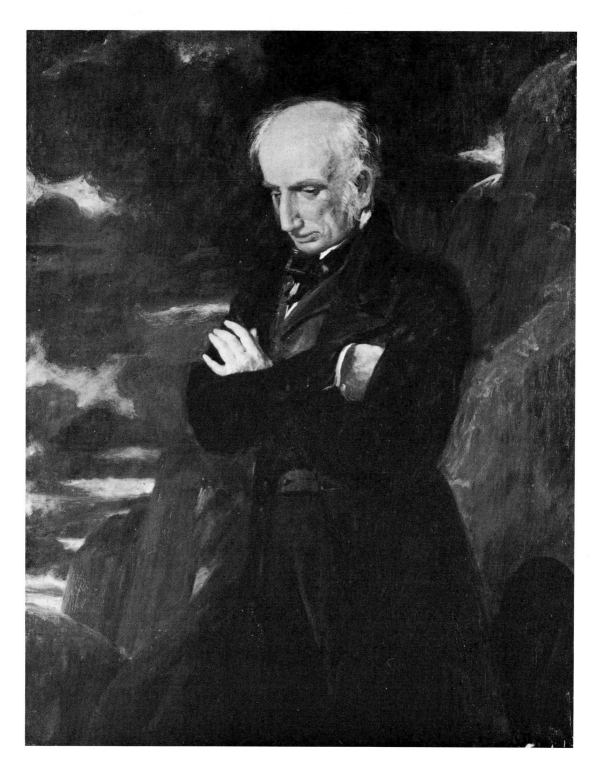

54 William Wordsworth (1770–1850) by Benjamin Robert
Haydon, 1842. Canvas, 124.5 × 99.1 (49 × 39)

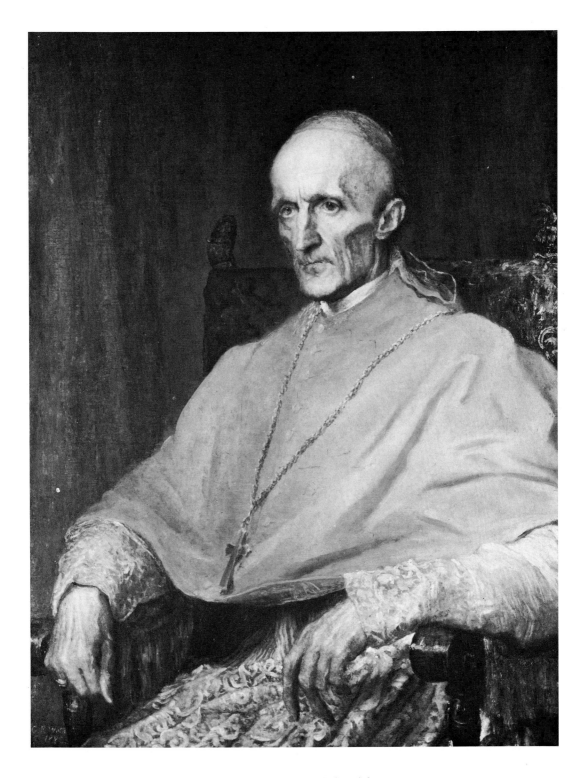

55 Cardinal Archbishop Henry Edward Manning (1808–92) by
George Frederic Watts, 1882. Canvas, 90.2 × 69.9 (35½ × 27½)

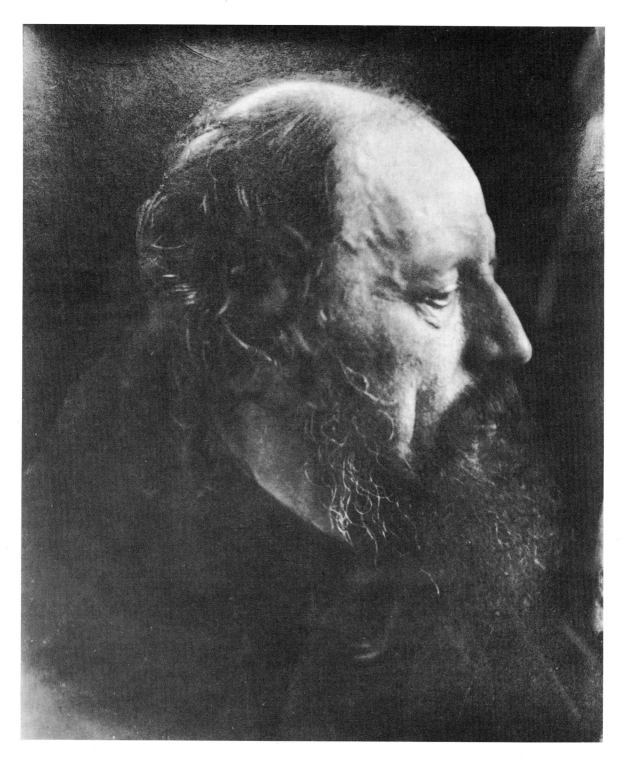

56 Alfred, Baron Tennyson (1809–92) by Julia Margaret Cameron,
1866. Collodion photograph, 26.7 × 22.2 (10½ × 8¾)

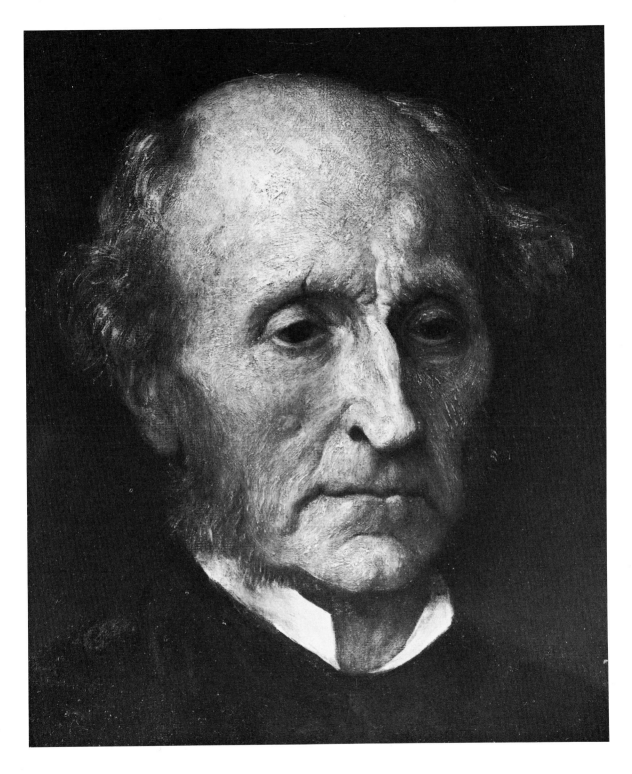

57 John Stuart Mill (1806–73) by George Frederic Watts, 1873.
(Detail, from canvas 66 × 53.3 (26 × 21))

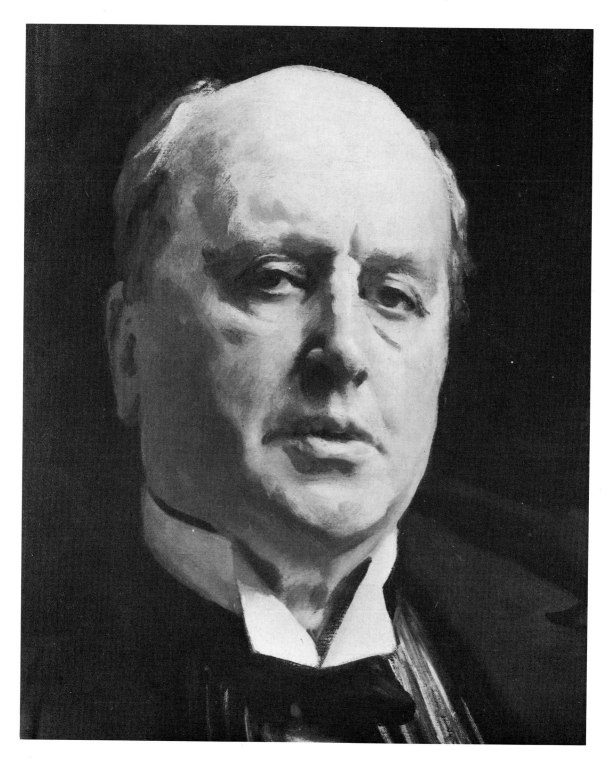

58 Henry James (1843–1916) by John Singer Sargent, 1913.
(Detail, from canvas 85.1 × 67.3 (33½ × 26½))

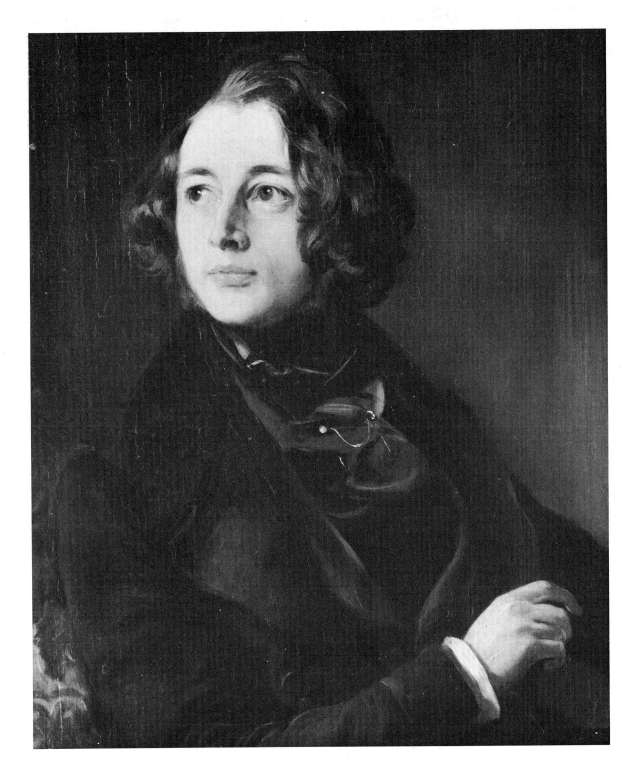

59 Charles Dickens (1812–70) by Daniel Maclise, 1838.
(Detail, from canvas 91.4 × 71.4 (36 × 28⅛))

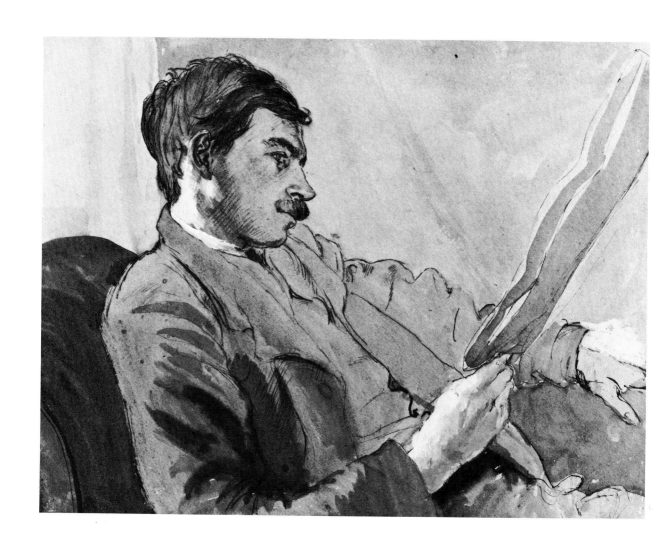

60 John Maynard Keynes, Baron Keynes (1883–1946) by Gwen
Raverat, *c.* 1908. Pen and water-colour, 27.9 × 36.8 (11 × 14½)

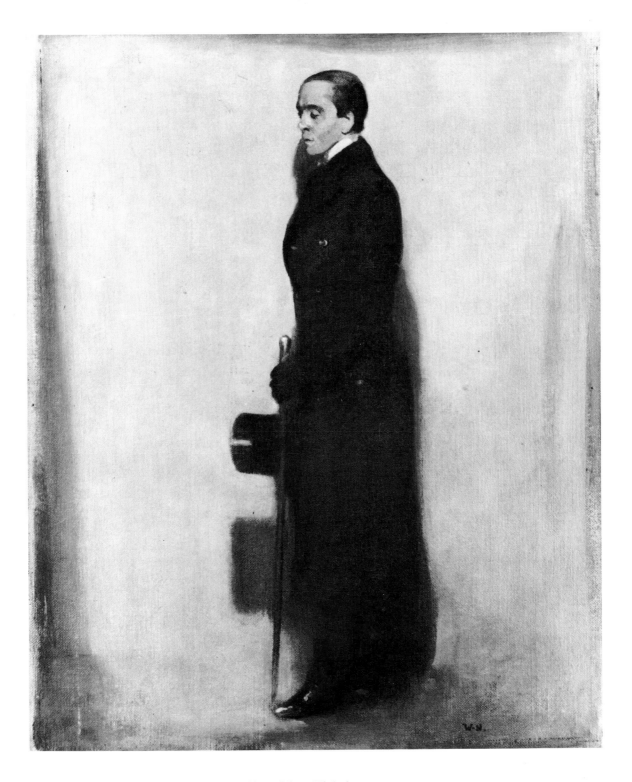

61 Sir Max Beerbohm (1872–1956) by Sir William Nicholson,
1905. Canvas, 50.2 × 40 (19¾ × 15¾)

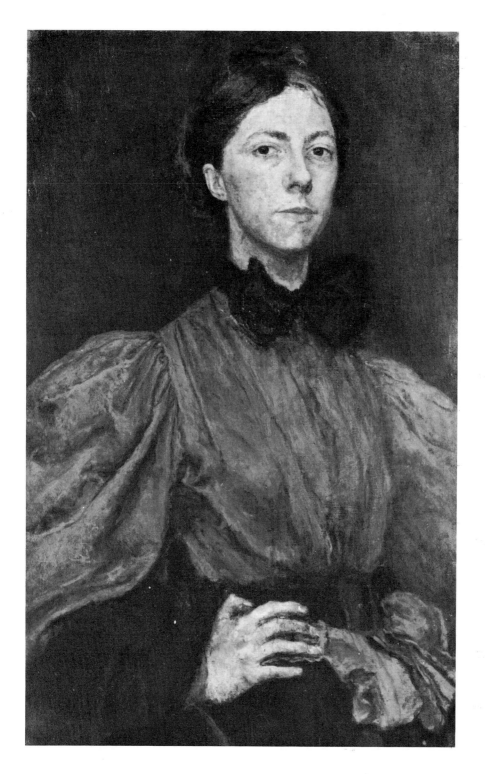

62 Gwen John (1876–1939), self-portrait, *c.* 1900. Canvas,
61 × 37.8 (24 × 14⅞)